DENZEL WASHINGTON

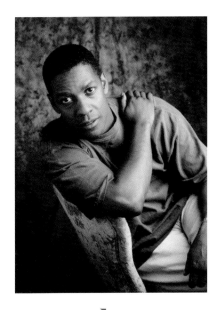

by
Jill C. Wheeler

Visit us at
www.abdopub.com

Published by ABDO & Daughters, an imprint of ABDO
Publishing Company, 4940 Viking Drive, Edina, MN 55435.
Copyright ©2003 by Abdo Consulting Group, Inc.
International copyrights reserved in all countries. No part of
this book may be reproduced in any form without written
permission from the publisher.

Printed in the United States.

Graphic Design: John Hamilton
Cover Design: Mighty Media
Cover photo: Corbis
Interior photos: AP/Wide World, p. 22, 25, 37, 57, 59, 62
 Corbis, p. 5, 7, 9, 10, 13, 15, 17, 18, 21, 27, 29, 30, 32, 35,
 38, 41, 45, 47, 49, 51, 53, 55, 60-61
 Tristar Pictures, p. 43, 48
 Universal Pictures, p. 42

Library of Congress Cataloging-in-Publication Data

Wheeler, Jill C., 1964-
 Denzel Washington / Jill C. Wheeler.
 p. cm. — (Star tracks)
 Includes index.
 Summary: Profiles a man whose talent and hard work
led him to a highly successful career as a television and film
actor, with five Academy Award nominations; more than any
other African-American actor.
ISBN 1-57765-772-1
 1. Washington, Denzel, 1954- —Juvenile literature.
2. Actors—United States—Biography—Juvenile literature.
[1. Washington, Denzel, 1954- 2. Actors and actresses.
3. African-Americans—Biography.] I. Title. II. Series.

PN2287.W452 W49 2002
791.43'028'092—dc21
[B]
 2001046148

CONTENTS

HARD WORK AND RAW TALENT

FORDHAM UNIVERSITY DRAMA PROFESSOR Robinson Stone couldn't take his eyes off the young actor playing the lead in *Othello*. An actor himself, Stone had seen the Shakespearean play many times. He'd even performed in it. But he'd never seen an actor portray Othello quite like this one. Stone waited for a famous line in the play, a line most actors shouted. This Othello whispered it. The impact sent a shiver through the audience.

Stone quickly called up a friend, and several agents. He told them they should come see the play. Soon they, like Stone, recognized the young actor's gift. "He was easily the best Othello I had ever seen," Stone recalled. He and his friends agreed young Denzel (pronounced den-ZEL) Washington had a brilliant career ahead of him.

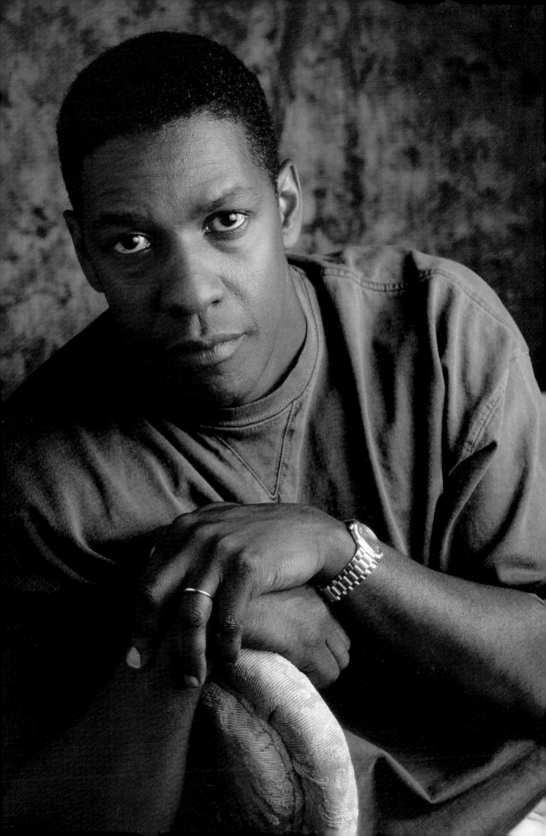

Washington didn't earn any money for his performance in *Othello* at Fordham. Today he commands more than $12 million per film. He's been nominated for five Academy Awards—the most of any African-American actor. Some refer to him as the leading African-American dramatic actor in Hollywood. Washington prefers to be considered one of Hollywood's leading dramatic actors, period. He's worked hard to show it's talent—not skin color—that makes the difference.

The *Los Angeles Times* concurred in 1995: "Among African-American actors, Washington is virtually alone in making the transition to the big-grossing, mainstream dramas that play equally well with urban audiences and the mostly white suburban-triplex crowd."

So how has Washington overcome Hollywood's color barrier? "I'm a positive thinker," he said. "People ask about the lack of work for black actors. I say, 'What about the lack of work for white actors?' I think if you're not happy with what's happening for you, go out and make something happen."

Indeed, Washington has made that his goal. "I am where I am by the grace of God," he said. "But I haven't had to do anything but work hard to get where I am."

He added, "I think if I wanted something put on my tombstone, I'd put 'Hard work is good enough.' "

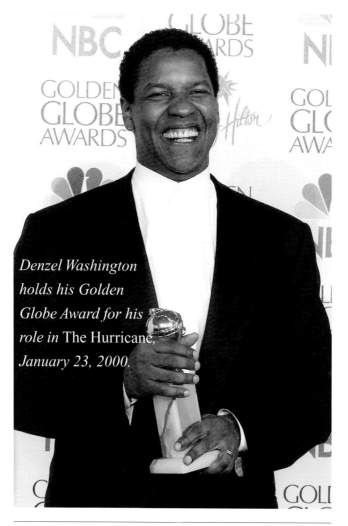

Denzel Washington holds his Golden Globe Award for his role in The Hurricane, *January 23, 2000.*

SUBURBAN
CHILDHOOD

DENZEL WASHINGTON WAS BORN ON December 28, 1954, in Mount Vernon, New York. He grew up with an older sister, Lorice, and a younger brother, David.

Denzel was named after his father, the Reverend Denzel Washington. Originally from Virginia, Reverend Washington was a Pentecostal minister. Though passionate about his ministry, he rarely had many people in his congregation on Sundays. Usually it was just the Washington family and a handful of others. "He was just a very, very spiritual guy," Denzel said of his father. "If there was one person in church and him, he was going to have a full-out service."

The rest of the week, Reverend Washington worked two jobs. One was at the S. Klein department store and the other was with the city water department. Denzel recalls he rarely saw his father except on Sundays in church. "He was gone when we got up and we were asleep when he got home every day."

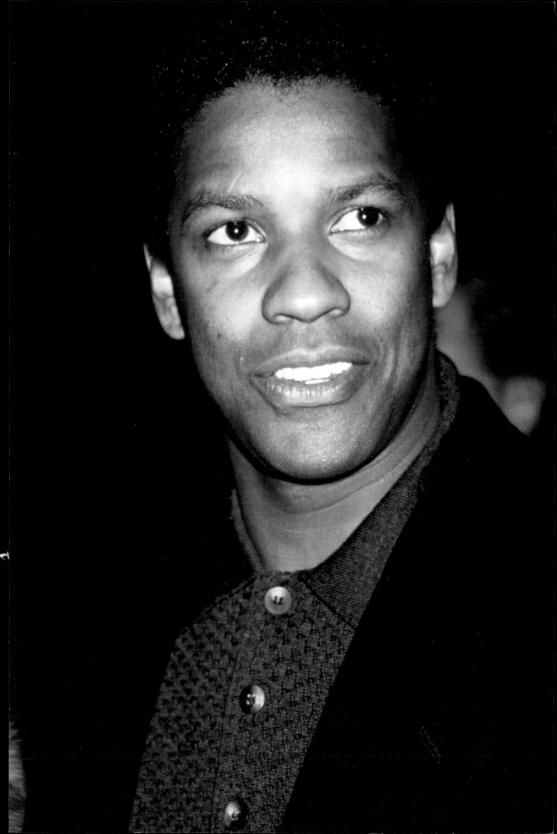

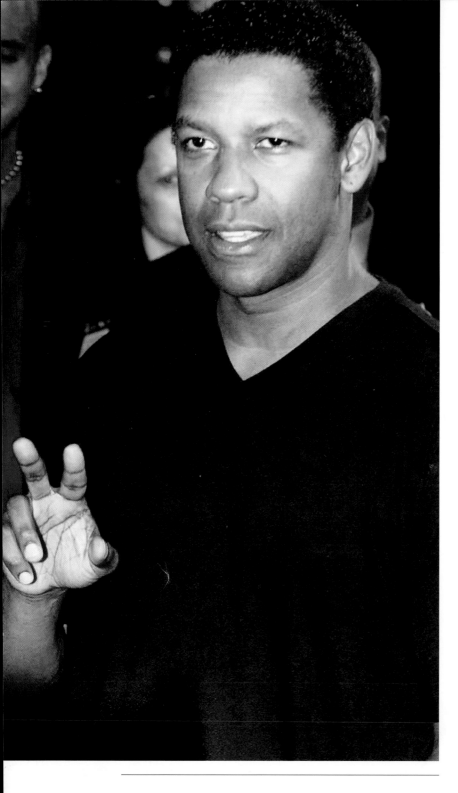

Denzel's mother, Lennis, was born in Georgia and raised in Harlem, New York. She was a former gospel singer and a talented businesswoman. At a time when many women did not work outside the home, Lennis owned and operated a successful beauty parlor. She eventually owned several.

"My mother's beauty parlor is her own stage where she performs matinees on a daily basis," Denzel said once. "The lives and lies you could encounter there every day were unbelievable." Around age 10, Denzel got into the act as well. He helped out at a barbershop of which his mother was part owner. He ran a whisk broom over people to dust off stray hairs and took their clothes to the cleaners. In return, they tipped him. "Everybody looked like a dollar bill to me," he said.

Mount Vernon was just north of New York City. Fortunately for Denzel and his family, it was a good place to live. It was not a desperately poor area. Neither was it racially segregated like many other areas. Denzel later described it as a buffer zone between the mean streets of New York City and the wealthy, primarily white suburbs to the north.

Denzel grew up alongside people from many racial and ethnic backgrounds. "It was a good background for someone in my business," he said. "My friends were West Indians, blacks, Irish, Italians, so I learned a lot of different cultures."

Like many other Mount Vernon residents, the Washingtons were middle class. They always had enough to eat and could pay their bills. Denzel even had enough money to sneak away occasionally to the movie theater. However, he truly had to sneak away. Reverend Washington only allowed his children to watch biblical movies like *The Ten Commandments*, along with some Disney movies. He did not approve of anything else.

Other than watching a few movies against his father's wishes, Denzel was well behaved. He spent a lot of time at the Mount Vernon Boy's Club hanging out with other young people and playing basketball and football. When he was 13, he served as a counselor at one of the club's summer camps.

There were a number of adult counselors at the Boy's Club as well. Denzel often went to them for advice. He recalls one of the counselors telling him that he could do anything he wanted when he grew up. Denzel believed that, and he never forgot it.

Denzel grew up
alongside people
from many racial
and ethnic
backgrounds.

ANGRY
YOUNG
MAN

DENZEL'S HAPPY CHILDHOOD COLLAPSED when he was 14. His parents divorced, and Reverend Washington moved back to Virginia. Suddenly Denzel, Lorice, and David were in a single-parent home. Denzel reacted violently. "I rebelled and got angry and started beating people up at school," he said. "I rejected everything." He began hanging out with a crowd of boys who often got in trouble with the law. At school, he went from being one of the top students in his class to being an underachiever.

Things might have gotten worse were it not for Denzel's mother, Lennis. "My mom's love for me and her desire for me to do well kept me out of trouble," he said. "When it came down to the moment of should I go this way or do that, I'd think of her and say: 'Naahh, let me get myself outta here before I get into trouble.' I think I was an actor, even back then."

Denzel found an outlet for his energies in sports and in the arts. At summer camps, he participated in several plays. He also played the piano. As a teen, he played briefly in a local soul band.

Many of Denzel's friends from the band were not so fortunate. One ended up dead. Several wound up in prison. One was crippled by alcohol and drug abuse. But Denzel escaped those fates. For that, he credits the Boy's Club and, most importantly, his mother. "She saw to it I was exposed to a lot of things," he said. "She is basically responsible for my success."

Lennis sent Denzel to boarding school when he was 14. On the advice of a school counselor, Lennis enrolled Denzel at Oakland Academy in New Windsor, a town in upstate New York. Most of the students at the private school were white children from wealthy families. Denzel received a partial scholarship to pay tuition, and Lennis scrimped and saved to make up the rest. She also sent Lorice to boarding school to save her from the temptations of New York City's streets.

Denzel Washington at the annual Publicists Guild Awards *in Beverly Hills, CA, March 22, 2000.*

At Oakland, Denzel was an average student. He still refused to work up to his potential, but he excelled at music and sports. The muscular, six-foot-tall young man was a natural athlete in track, basketball, baseball, and football. Yet he didn't want to pursue athletics for a career. He didn't know what he wanted to do.

Denzel took six months off from college to figure out what he really wanted to do.

When he graduated from high school in 1972, Denzel applied to Yale University, Boston University, and Fordham University. He was not accepted at Yale, and he couldn't come up with enough money to attend Boston University. So Denzel went to Fordham University in New York's Bronx section. Attending Fordham cost less than many other schools. Still, Denzel had to run an after-school child care service at a local church to pay his tuition.

Denzel enrolled in Fordham's pre-med program. But he soon realized medicine was not the field for him. He did, however, enjoy his Introduction to Communications course, so he switched his major to journalism. He also began to dabble in writing poetry. Meanwhile, he competed head-to-head on the athletic field with students on athletic scholarships.

Denzel liked his new major, but it still wasn't a calling for him and his grades showed it. After a year and a half at Fordham, he decided to take six months off from college to figure out what he really wanted to do.

FINDING HIS NICHE

DURING HIS TIME OFF, WASHINGTON joined the 9-to-5 work world, taking jobs but not really planning a future. "I was just sort of floundering," he recalled. "I worked at the post office for awhile. I worked at the sanitation department, collecting trash. I thought, 'Whoa, I gotta get back to college!'"

Washington decided to return to school that fall. Meanwhile, he took a summer job as a counselor at a YMCA camp in Lakeville, Connecticut. It was the same camp he'd attended as a teenager. The staff invited him back to help with the athletic and drama programs. They remembered Washington's talents in both areas.

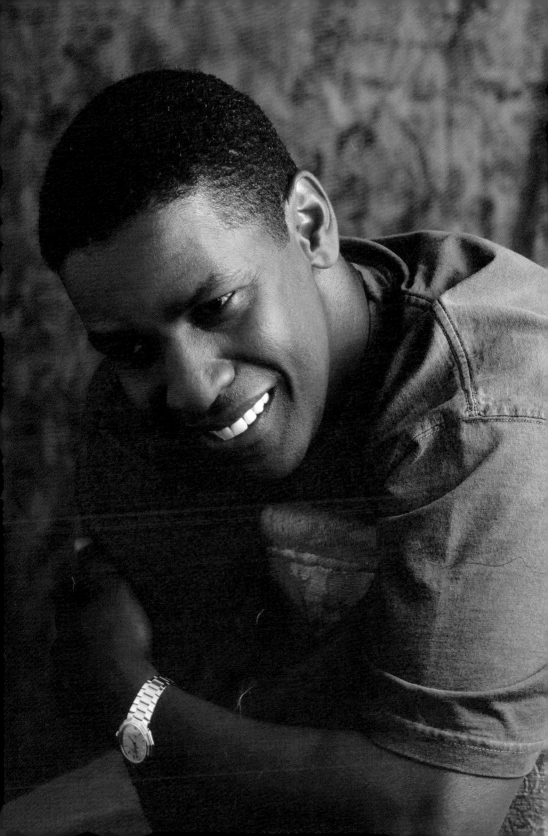

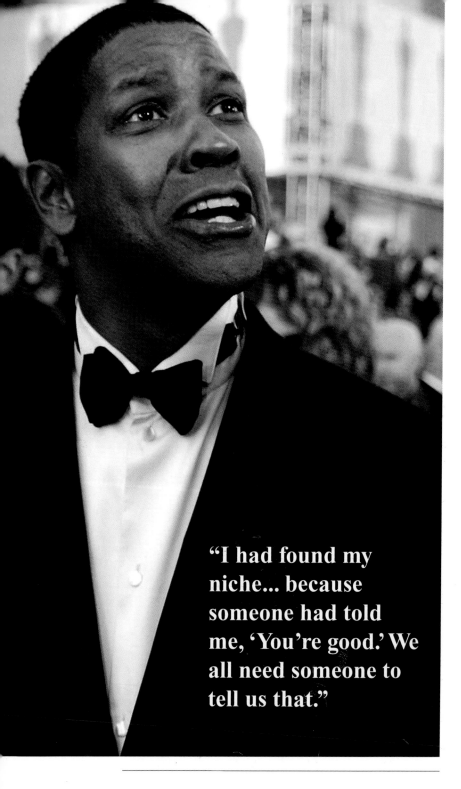

"I had found my niche... because someone had told me, 'You're good.' We all need someone to tell us that."

At camp, Washington and the other staff members took part in a play for the campers. The other counselors quickly realized he had a special gift. On stage, Washington was completely at ease. He also generated a special presence that captivated his audience. They suggested to Washington that he consider doing more acting.

Washington took their advice. When he returned to Fordham, he auditioned for and won a part in the school's production of *The Emperor Jones*. As he explains it, he wasn't nervous because he had no idea what he was doing. "I'm more afraid now," he said. "I know what can go wrong." For young Washington, his first night on stage in front of an audience was no more nerve-racking than performing for the children at the YMCA camp.

From that point on, Washington had a calling. He began taking drama courses and appearing in productions at Fordham. He pulled his grade-point average up from a low 1.6 to a 3.8. A 4.0 grade-point-average means a student has earned straight A's. "I had found my niche," he explained. "Again, it was because someone had told me, 'You're good.' We all need someone to tell us that."

It was in his senior year that Washington landed the lead in *Othello*. One of the talent agents that saw his performance helped the young actor land his first part in a made-for-television movie about the life of Wilma Rudolph. Rudolph was an African-American woman who triumphed over polio to become a track star and Olympic athlete. In the movie, Washington played Wilma Rudolph's boyfriend, who later becomes her husband.

It was a small part for Washington, and it didn't do much for his career. But it introduced him to an actress in the movie. She was an accomplished singer and pianist named Pauletta Pearson. Washington didn't get much time to get to know Pearson, but he didn't forget her. Something about her struck him and stuck with him.

Shortly after filming the movie, Washington graduated from Fordham with a double major in journalism and drama. He then headed west to San Francisco, California. He had been accepted for two years of study at the American Conservatory Theater (ACT).

STARVING

ARTIST

WASHINGTON WANTED TO ATTEND ACT to improve his acting skills. He wasn't alone. More than a thousand people had applied to study there. Only 45 were accepted.

Washington moved to San Francisco with only about $800 in his pocket. He quickly got an apartment and a job in a restaurant. "I knew enough to get a job at a restaurant so I could eat," he said. He also began studying acting, dancing, and scene design at ACT. But he quickly grew bored. A natural actor, it wasn't long before he felt like he knew enough. He felt ready to take on work outside the classroom and outside ACT.

At ACT, Washington had landed many leading roles in plays. Now, he wanted to do movies. He moved to Hollywood and auditioned for film parts. Competition was stiff, and no one had heard of Denzel Washington. After many rejections, Washington decided he should do more work on stage to make a name for himself. Then he would try his hand at movies again.

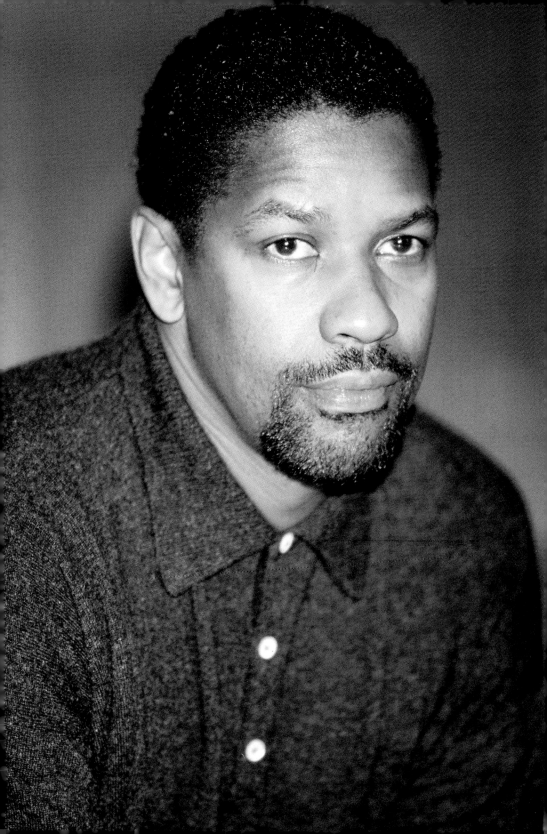

Washington moved back in with his mother in New York and started looking for work in live theater. In one sense, he was fortunate. It was the late 1970s. At that time, there were many theater opportunities for African-Americans. Before, most African-American actors were only allowed to play parts specifically written for African-Americans. But in the 1970s, playwrights created new works specifically for all-black casts.

Washington took full advantage of these opportunities, appearing in many off-Broadway productions. He also appeared in Shakespeare in the Park productions in New York City's Central Park. During this time, he again met Pauletta Pearson at a party. The two began dating, and later Pearson moved in with Washington and his mother. Washington admits that in their early years together, Pearson was making most of the money. She was finding regular work singing and acting on Broadway.

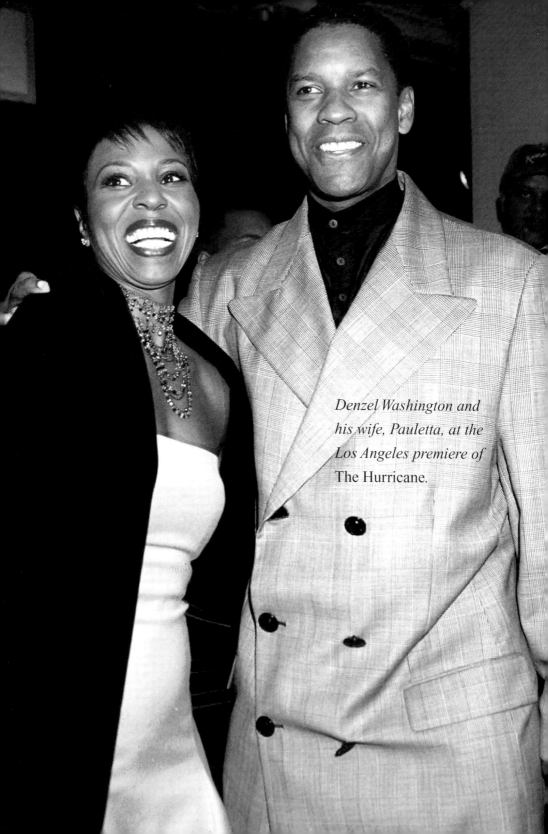

Denzel Washington and his wife, Pauletta, at the Los Angeles premiere of The Hurricane.

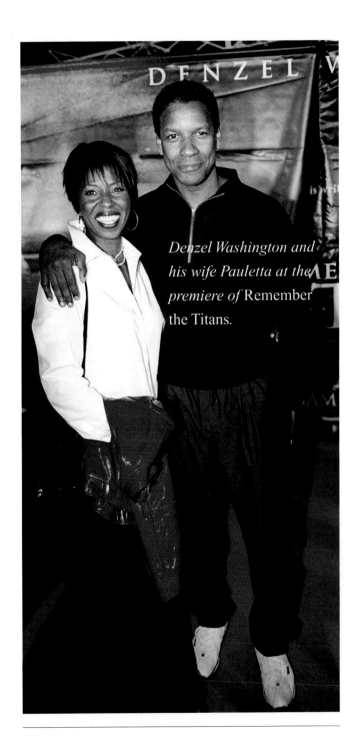

Denzel Washington and his wife Pauletta at the premiere of Remember the Titans.

In 1979, Washington received what he thought might be his big break. He auditioned for and received a featured role in the made-for-television movie *Flesh & Blood*. In *Flesh & Blood*, he played a boxer alongside actor Tom Berenger. The role gave him national exposure, plus a nice paycheck. Washington was confident it would lead to more offers. Sadly, it did not. After several months of rejections, he applied for a job with the county recreation department. He was ready to give up acting, but Pearson convinced him otherwise. "She was the one who said I should keep going," he said. "She was the one who said, 'Just keep trying.' "

Washington took her advice. One week before he was to report for his new job, he landed the role of Malcolm X in a new off-Broadway play, *When the Chickens Came Home to Roost*. Washington didn't know much about African-American leader and activist Malcolm X. He quickly dived into the role. He researched Malcom's life, watched film footage of him, and listened to tapes of him speaking. He even dyed his hair red like Malcolm's had been.

Washington performed in *When the Chickens Came Home to Roost* 12 times. That was all it took. He had been noticed, and he was invited to join the famed Negro Ensemble Company. Two weeks after finishing his run as Malcolm X, Washington was in rehearsals for *A Soldier's Play*.

A Soldier's Play is about an all-black company of the United States Army during World War II. The story revolves around the murder of an African-American soldier and the resulting investigation. Washington earned an Obie Award in 1980 for his performance in *A Soldier's Play*. The Obie is one of the highest honors an actor can achieve performing off-Broadway.

ST. ELSEWHERE

BEFORE *A SOLDIER'S PLAY*, WASHINGTON had gone back in front of the camera to act with George Segal in *Carbon Copy*. The movie opened two months before *A Soldier's Play* opened. In *Carbon Copy*, Washington plays the illegitimate son of a white executive.

Carbon Copy isn't a very good movie. But Washington's strong performance caught the attention of producer Bruce Paltrow. Paltrow, the father of actress Gwyneth Paltrow, was looking for someone to star in a new television series. The show, *St. Elsewhere*, was about a run-down hospital in Boston, Massachusetts. He wanted Washington to play Dr. Phillip Chandler.

Throughout his career, Washington had avoided taking stereotypical African-American roles. He turned down a number of roles because the characters were drug addicts or hoodlums. Washington wanted to be considered an actor first, not an African-American who happened to be an actor.

The Dr. Chandler role in *St. Elsewhere* appealed to Washington for several reasons. One was because Chandler was a successful, Yale-educated physician. The other was because Chandler was a secondary role.

Playing a secondary role gave Washington the time to pursue other acting opportunities while still getting a steady—and bigger—paycheck. By the end of the show's run Washington was earning nearly $30,000 per episode. In comparison, he'd earned just $700 for all 12 performances of *When the Chickens Came Home to Roost*.

"I wasn't crazy about doing a series, because I just thought you'd get burned out, you'd get too popular," Washington said. "But I was tired of breaking my behind for no money. I went to L.A. thinking 'This is only going to be for 13 weeks anyway.' "

The 13 weeks turned into six years. *St. Elsewhere* became a critically acclaimed series that won 12 Emmy Awards. Fortunately for Washington, his plan to remain open to other opportunities worked beautifully. In 1984, director Norman Jewison made a movie out of *A Soldier's Play*. *A Soldier's Story* featured several of the actors from the off-Broadway production, including Washington. Critics liked the movie, and they noted that Washington was a standout.

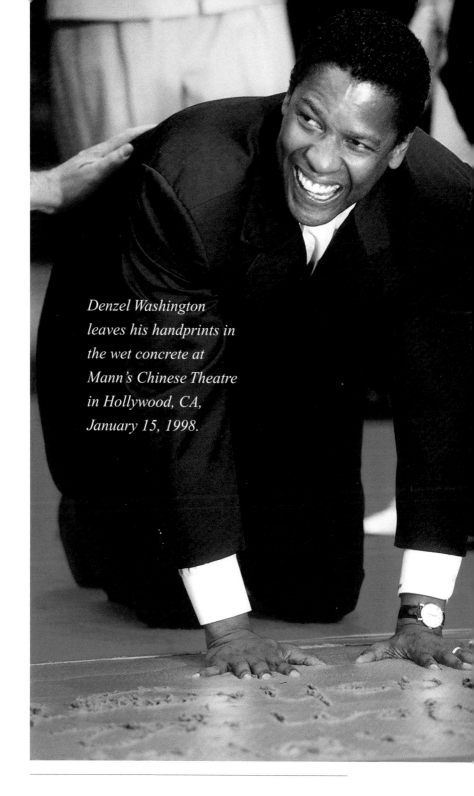

*Denzel Washington
leaves his handprints in
the wet concrete at
Mann's Chinese Theatre
in Hollywood, CA,
January 15, 1998.*

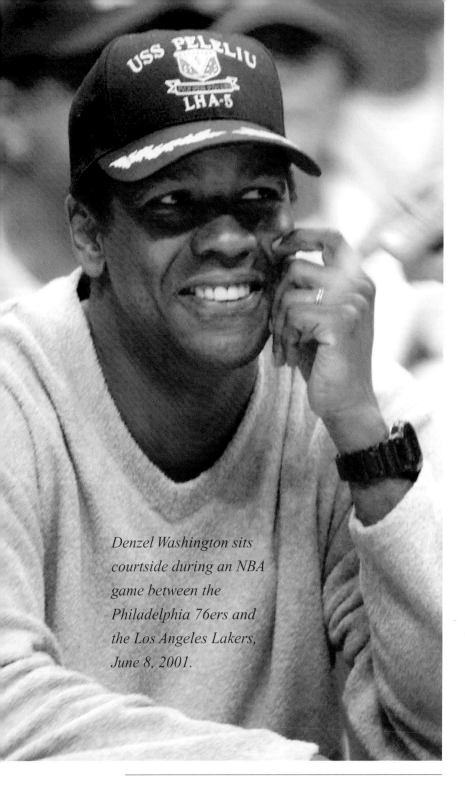

Denzel Washington sits courtside during an NBA game between the Philadelphia 76ers and the Los Angeles Lakers, June 8, 2001.

In the 1980s, Washington took on a number of other roles. He played an assistant district attorney in 1984's made-for-television movie *License to Kill*. He played the title role in the 1986 movie *The George McKenna Story*, about a real-life principal who reforms a troubled inner-city school. He also starred in 1986's *Power*. The movie showed what trouble can arise when business interests and politics collide. It also was a special accomplishment for Washington. The role he played had been scripted for a white actor. Washington proved it was acting ability—not race—that would make or break the part.

Off screen, Washington's personal life also was picking up speed. He and Pearson had married in 1983, after Washington proposed to her over the telephone. Now the couple had a son, John David. Once, Washington arranged for John to play the part of an infant in *St. Elsewhere*. Washington promptly took the $400 his son earned and put it in a savings account for him. After several years on *St. Elsewhere*, Washington was able to buy his mother a new car—with cash. It was something he'd only dreamed of before.

BRINGING
BLACK
HISTORY
TO LIFE

WASHINGTON'S NEXT PROJECT TOOK HIM
to Africa. He was going to play South African activist
Steve Biko in the movie *Cry Freedom*. Biko had
been one of many black activists fighting apartheid
in South Africa. Apartheid was the South African
system of keeping blacks and whites separate and
unequal. Biko was killed because of his activism.

In *Cry Freedom*, Washington starred alongside
Kevin Kline. Kline played the white journalist who
told the world about Biko's murder. To prepare for
the part, Washington gained 30 pounds. He read
about Biko, studied tapes of his speeches, and
mastered a South African accent. The movie was
filmed in Zimbabwe and Tanzania. This meant long
trips back to Hollywood to film *St. Elsewhere*, and
long hours away from his family. But it was an
opportunity for Washington to make a movie about
an important event in black history.

Cry Freedom received mixed reviews. About the only thing the critics agreed on was that Washington's performance was exceptional. He earned an Academy Award nomination for best supporting actor.

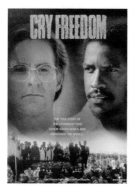

In 1988, Washington returned to the stage for the comedy-drama *Checkmates*. The story is about two African-American couples who share a house. Though his character had many bad habits, critics admitted Washington played him well. In 1988, Denzel and Pauletta had a daughter. They named her Katia.

In 1989, Washington dropped the South African accent for an English one. In *For Queen and Country*, he played a British soldier who returns home to a crumbling community after fighting in the Falkland Islands. The film was not shown widely in the United States. That same year he played the lead in *The Mighty Quinn*, a romantic thriller set in the Caribbean.

Also in 1989, Washington appeared in the acclaimed Civil War movie *Glory*. The movie was about the first African-American Army unit in the Civil War. Washington said he hadn't known there

had been African-American soldiers in the war. He learned about that and many other Civil War events while researching his part.

In *Glory* Washington played an uneducated, bitter former slave turned soldier. He had some reservations about taking the role. As he said in an interview, he had been "hesitant about doing quote unquote slave films, but the bottom line is that as a black American, that's my history, and this isn't one."

Once again Washington was nominated for an Academy Award for best supporting actor. This time, he won. It made him only the fifth African-American actor to win an Oscar. More importantly to Washington, his work in *Glory* led to a National Association for the Advancement of Colored People (NAACP) Image Award for best supporting actor.

NEW ROLES, OLD ROLES

AFTER DOING THREE DRAMATIC FILMS IN one year, Washington opted for a change of pace. He next appeared in the light-hearted, but poorly received, comedy *Heart Condition*. Then in 1990, he appeared as a trumpet player in director Spike Lee's *Mo' Better Blues*. Washington even learned how to play the trumpet for the part. The role also gave him a chance to play a romantic lead for a change.

After *Mo' Better Blues*, Washington returned to the stage. He took a role that he described as his most challenging yet. It was the lead in Shakespeare's *Richard III*. He followed that in 1991 with another movie. In *Ricochet* Washington played a police officer who becomes an attorney. That same year, Washington's father died. While Washington was saddened by the news, his father had not been much of a part of his life for many years.

Washington received further acclaim for his role in 1992's *Mississippi Masala*. It's the story of a romance between an African-American man and an Indian woman in a small Southern town. Washington loved the story so much he agreed to do the movie for one-quarter of his usual salary. Critics said it was worth it, and the NAACP gave Washington another Image Award, this time for best actor.

That same year, Washington reprised his role of Malcom X. This time it was in Spike Lee's film of the same name. Washington had worked hard the first time he played Malcolm X on stage. He worked even harder in preparation to play him on the big screen. He knew millions more people would be watching this performance. He spent 12-hour days reading speeches, watching videotape, and working with members of Malcom X's former organization. For his work in *Malcolm X*, Washington received another Academy Award nomination for best actor, as well as a Golden Globe Award and an NAACP Image Award.

While Washington had done Shakespeare on stage, he had not yet done it on film. He got his chance in 1993 with *Much Ado About Nothing*. Washington's character, Don Pedro, is typically considered to be white. Once again, Washington's abilities helped him break down racial prejudice.

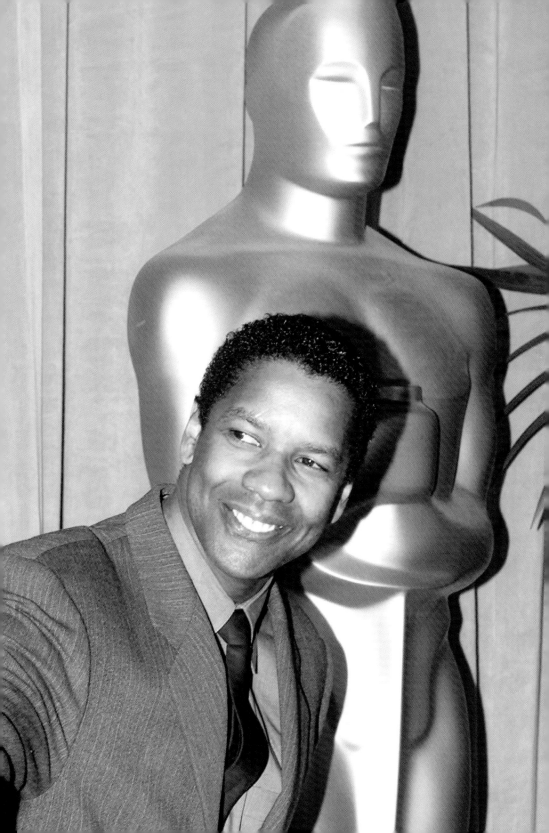

Washington faced a different kind of prejudice in his next film. This time, it was his own character who was prejudiced. In *Philadelphia*, Washington played an attorney reluctant to take on a client, played by Tom Hanks, because the client is a gay man with AIDS. In the end, Washington's character must address his prejudices and re-evaluate his beliefs. Washington's wife also got into the act, contributing a song to the *Philadelphia* soundtrack.

Washington followed the success of *Philadelphia* with three more films in quick succession. He starred in *The Pelican Brief* with Julia Roberts, with Gene Hackman in *Crimson Tide*, and played opposite a computer-generated villain in *Virtuosity*. At home, he now had four children, including twins Olivia and Malcolm.

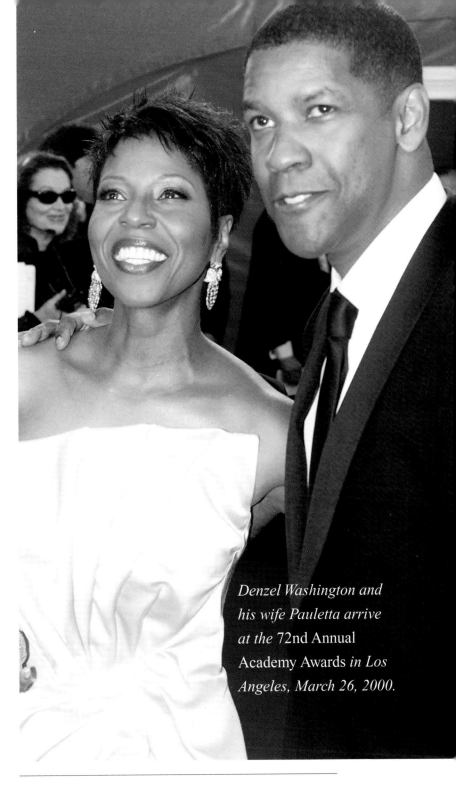

Denzel Washington and his wife Pauletta arrive at the 72nd Annual Academy Awards *in Los Angeles, March 26, 2000.*

IN THE
PRODUCER'S
CHAIR

IN THE EARLY 1990S, WASHINGTON FORMED his own production company, Mundy Lane Entertainment. The name comes from a street on which he once lived. Washington started the company to produce quality films and increase opportunities for African-American actors.

For the company's first major release, Washington chose a movie based on a book. *Devil in a Blue Dress* was written by African-American mystery writer Walter Mosley. The main character, private investigator Easy Rawlins, seemed to have been written especially for Washington.

Just prior to filming *Devil in a Blue Dress*, the Washington family took a much needed vacation to Africa. They traveled, camped, went on safaris, and met South African President Nelson Mandela. A highlight of the trip was when Denzel and Pauletta renewed their wedding vows with South African Archbishop Desmond Tutu.

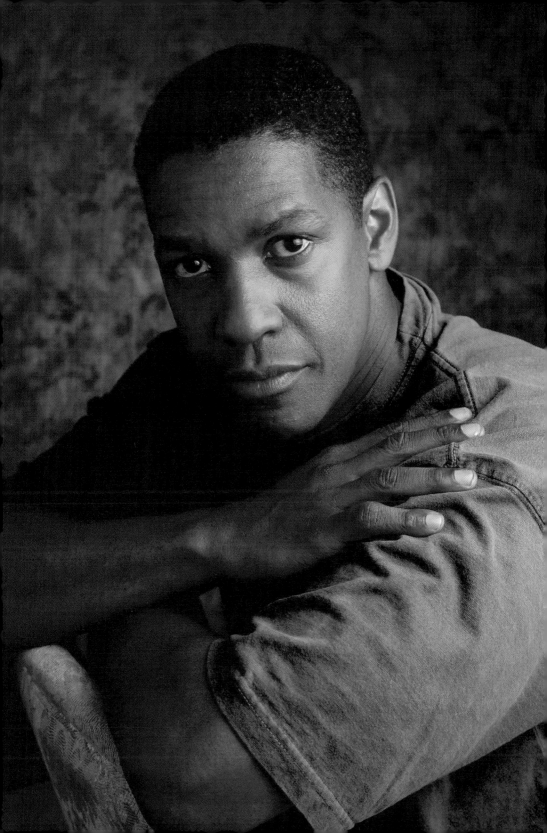

Once back in Hollywood, Washington immediately went to work on *Devil in a Blue Dress*. He then starred with Meg Ryan in the action film *Courage Under Fire*. Next, he went on to produce and star in *The Preacher's Wife* with Whitney Houston.

The Preacher's Wife was a remake of a sentimental 1940s film starring Cary Grant. Washington played Grant's old role of an angel who helps Houston's character. Many people thought the film was a big departure from his usual work. "I've done enough films that have the edge, drama, weight, and all that," he said. "I just thought we had an excellent opportunity to talk about faith and family."

The Preacher's Wife hit theaters in 1996. In 1998, audiences saw Washington in three films: *Fallen*, *He Got Game*, and *The Siege*. In 1999, Washington appeared in *The Bone Collector* and *The Hurricane*.

In *The Hurricane*, Washington plays Rubin "Hurricane" Carter, an African-American boxer who was convicted of a triple murder he didn't commit. Carter spent 20 years in prison before his name finally was cleared of the crime.

For the role of Carter, Washington went on an intensive six-month training schedule. He lost 40 pounds in the process. He also transformed his body—and his mind—to play the wrongly convicted boxer. Washington's performance was electrifying, and it earned him yet another Academy Award nomination for best actor.

Washington's next effort, in 2001, was a Disney movie titled *Remember the Titans*. The film was based on the true story of one of the first integrated football teams in Virginia. Washington played the coach that united a community and a team in the normally segregated 1970s.

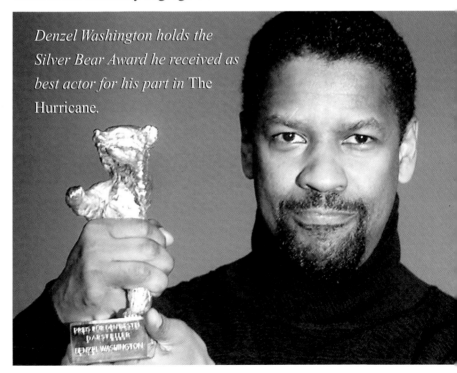

Denzel Washington holds the Silver Bear Award he received as best actor for his part in The Hurricane.

A
LEADING
MAN

SOME FANS HAVE COMPLAINED THAT
Washington won't do romantic roles. Certainly,
with his movie-star looks, he could. "A good love
story is one of the things I'm looking to do down
the road," he explained. "I just haven't found the
right script."

He does play a romantic lead at home. Denzel
and Pauletta have one of the few Hollywood
marriages that have stood the test of time. This is
despite the fact that Washington has thousands of
adoring female fans. He still finds his sex symbol
image puzzling. "I don't see it," he says. "Nobody
in my house buys into it. My wife is like, 'Okay,
Mr. Sex Symbol, why don't you try putting some
gas in the car; why don't you charm that attendant
into filling up the tank?' "

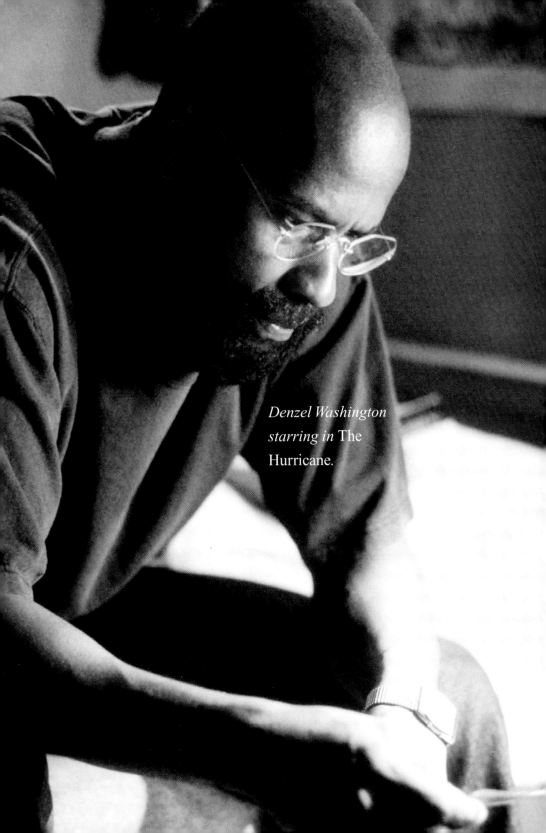

Denzel Washington
starring in The
Hurricane.

Washington also remains devoted to his children. He has provisions written into his movie contracts that allow him to go home on weekends. In between movies, he coaches Little League teams and drives his kids to their appointments like millions of other fathers. He and his family live in Beverly Hills, California.

Washington works hard to keep his private life private. In his time off, he is much like an ordinary guy. He enjoys playing football, tennis, and basketball, as well as skiing, running, and weight lifting. He also wants his children to have as normal an upbringing as possible.

He and Pearson regularly donate money and time to charities for everything from people with HIV (the virus that causes AIDS), to senior citizens, to children in South Africa.

When asked what his priorities are, Washington replied "God, family, work. Football." He has retained the religious faith he learned from his parents. He reads *The Daily Word* each day and serves as national spokesperson for the Boys & Girls Club of America.

In the fall of 2001, Washington starred in *Training Day*. The movie tells the story of veteran Los Angeles police officer Alonzo Harris, played by Washington. In the movie, Washington takes a new police officer, played by Ethan Hawke, through his first day on an inner-city beat. For his riveting performance, Washington received his third Academy Award nomination for best actor.

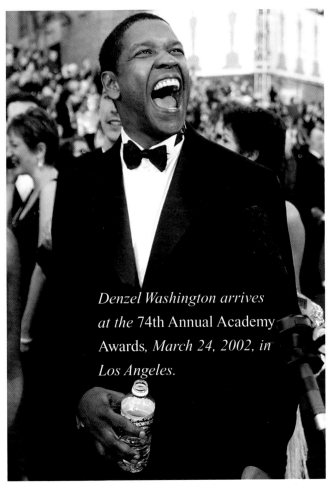

Denzel Washington arrives at the 74th Annual Academy Awards, *March 24, 2002, in Los Angeles.*

Washington's first film in 2002 was *John Q.* In the movie, Washington plays John Q. Archibald. John Q. takes a hospital emergency room hostage when administrators deny healthcare to his son Mike, played by Daniel E. Smith.

In March 2002, at the 74th Annual Academy Awards, Washington finally won the Oscar for best actor for his performance in *Training Day*. He is only the second African-American to win the best actor award. The first was Sidney Poitier, who won the best actor prize in 1963 for his performance in *Lilies of the Field*.

The same night Washington won, Poitier was also honored with an honorary award for his contribution to the film industry. "Forty years I've been chasing Sidney," Washington lightheartedly said of being the second African-American to win the best actor statuette. "They finally give it to me, and they give it to him on the same night!"

Washington has had a successful career, but he keeps his work in perspective. Washington says he treats his movies much like his fans do. Speaking about the impact of *The Hurricane*, he says, "I know how Rubin's story affected my life. But for most people, it's just a movie.

"And at the end of it, they go back to doing what they do, and I go on to another movie and back to being a husband, a son, and a dad."

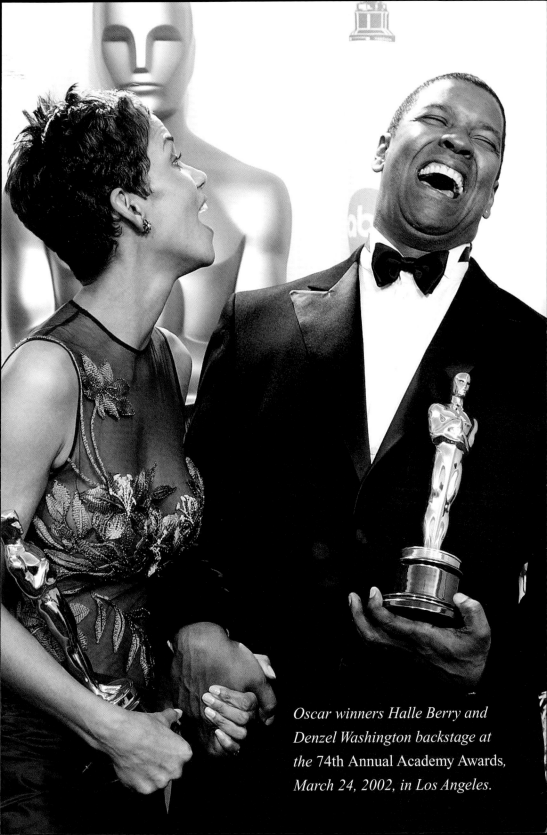

Oscar winners Halle Berry and Denzel Washington backstage at the 74th Annual Academy Awards, March 24, 2002, in Los Angeles.

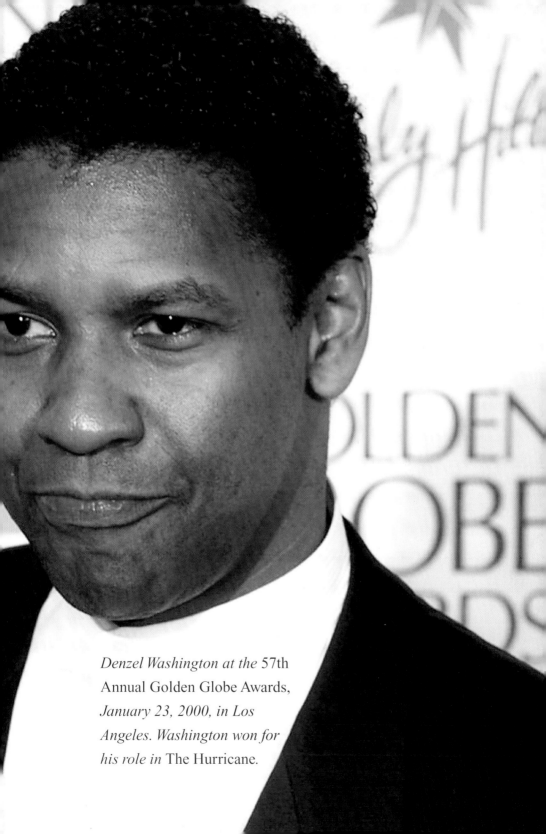

Denzel Washington at the 57th Annual Golden Globe Awards, January 23, 2000, in Los Angeles. Washington won for his role in The Hurricane.

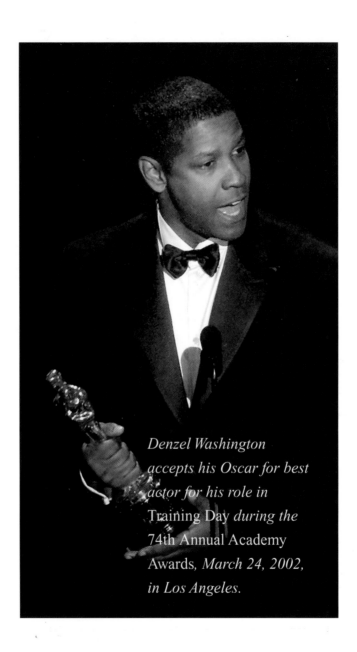

Denzel Washington accepts his Oscar for best actor for his role in Training Day *during the 74th Annual Academy Awards, March 24, 2002, in Los Angeles.*

GLOSSARY

apartheid: a policy of racial segregation formerly found in South Africa.

illegitimate: born of unmarried parents.

off-Broadway: plays performed in smaller playhouses that are not considered to be a part of the official Broadway theater district in New York City.

Pentecostal: a group of churches that believe in conservative ideals.

WEB SITES

Would you like to learn more about Denzel Washington? Please visit **www.abdopub.com** to find up-to-date Web site links about Denzel Washington and his film and television career. These links are routinely monitored and updated to provide the most current information available.

INDEX